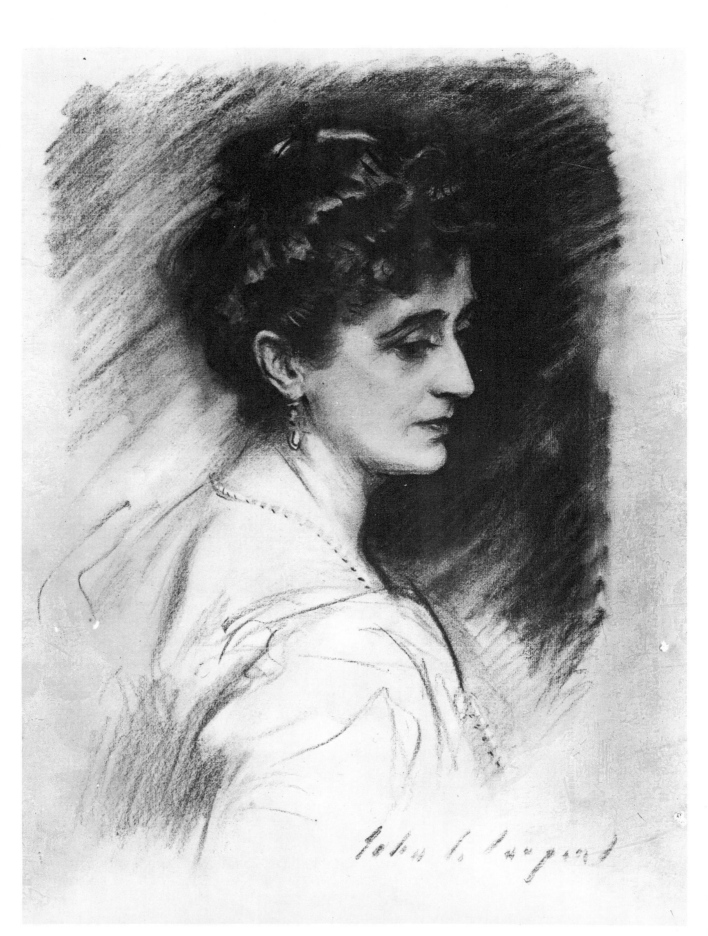

THE HON. MRS. GILBERT LEGH, ca. 1902. Private collection.

SARGENT
PORTRAIT DRAWINGS
42 Works by John Singer Sargent

Selected and with an Introduction by
Trevor J. Fairbrother

Dover Publications, Inc., New York

Technical Note and Acknowledgments

All works on paper and, unless otherwise stated, executed in charcoal. The dimensions of the sheets are given in inches, height before width. In the few cases in which dimensions are not provided, the approximate size of the sheet is 25 x 18 inches.

The following works were bequeathed to their respective museums in the following names: Plate 1, Mrs. Francis Ormond; Plates 4, 10, 19, 20, Grenville L. Winthrop; Plates 5, 7, 8, 11, 29, Miss Emily Sargent and Mrs. Francis Ormond; Plate 6, Annie Swan Coburn; Plate 9, Edwin Austin Abbey Memorial Collection; Plate 38, Paul H. Manship; Plate, 40, Mary van Kleck, 1954.

The author wishes to thank the many people who have been generous with their help, in particular Deborah Gribbon, Peter Inskip, John T. Kirk, Alison Neville, Richard Ormond, Derek Shrub, Theodore E. Stebbins, Jr., Miriam Stewart, John Sunderland, William L. Vance and several private owners of Sargent drawings. The Witt Library of the University of London went to great trouble to provide the Frontispiece and Plates 14, 15, 18, 22, 23, 26, 27, 28, 30, 31 and 37, and I am most grateful.

Copyright © 1983 by Trevor J. Fairbrother.

Published in Canada by General Publishing Company, Ltd., 30 Lesmill Road, Don Mills, Toronto, Ontario.
Published in the United Kingdom by Constable and Company, Ltd.

Sargent Portrait Drawings: 42 Works is a new work, first published by Dover Publications, Inc., in 1983.

Manufactured in the United States of America
Dover Publications, Inc., 180 Varick Street, New York, N.Y. 10014

Library of Congress Cataloging in Publication Data

Fairbrother, Trevor J.
 Sargent portrait drawings.

 (Dover art library)
 1. Sargent, John Singer, 1856–1925 — Catalogs.
I. Sargent, John Singer, 1856–1925. II. Title.
III. Series.
NC139.S27A4 1983 741.973 83-5236
ISBN 0-486-24524-1

Introduction

John Singer Sargent (1856–1925) was born in Florence of wealthy American parents who had moved to Europe from Philadelphia in 1854. While the family traveled between cultural centers and spas his talent for drawing was encouraged by his mother, an amateur sketcher, and by artist friends of his parents. At 14 he began to attend drawing classes at the Accademia delle Belle Arti in Florence; and his professional training as a painter began in 1874 when he was admitted into the atelier of the Parisian artist Carolus-Duran. Here he learned the loose, painterly style associated with the new interest in the seventeenth-century bravura artists Velasquez and Hals. Vivid brushwork and an intuitive eye for his subjects' characteristic gestures brought Sargent rapid international acclaim as a leader in modern portraiture. By 1890 he had settled in London, having already worked in Paris, New York and Boston, commanding high prices from fashionable sitters. That year he accepted a commission to decorate a hall in the new Boston Public Library, and for the rest of his career worked on this and major mural projects at Harvard University and the Museum of Fine Arts, Boston. At the turn of the century he began to make many informal pictures during travels in Italy, Spain, the Alps, the Near East and North America. It is often suggested that these brilliantly spontaneous watercolors and paintings signal his having tired of professional portraiture. In fact he never stopped making portraits; instead of time-consuming oil paintings he came to prefer charcoal drawings that could be produced in a single sitting about two hours in length. From 1910 to his death in 1925 he made over 500 such drawings, while painting fewer than 30 oil portraits.

This selection of portrait drawings begins with Sargent's arrival in Paris. Plate 1 shows an 1874 sketch of a fellow student at Carolus-Duran's atelier, the American J. Carroll Beckwith. Concern for a strong facial likeness is evident, but already a rapid and suggestive execution can be seen in the clothes and accessories. The 1880 drawing of another American artist and friend, Gordon Greenough (Plate 2), shows Sargent's developing technical abilities when compared with the sketch of Beckwith. The climax of his Parisian career was the Salon debut of *Mme. Pierre Gautreau*, now known as *Mme. X*, in 1884: this chilling display of the cosmetic and décolleté extremes of a fashionable beauty provoked a brief scandal in high society and adversely affected commissions from the French. Two of the preliminary drawings of Mme. Gautreau demonstrate a genuine attraction to the subject not readily apparent in the finished portrait. Plate 4 captures her seated in the now-famous evening gown, luxuriant, self-absorbed and unthreatening. In Plate 5 the artist presents her as in a Renaissance profile portrait, conscious of the tender eyes, exquisitely formed nose and lips and her extraordinary neck. (Surely Sargent was remembering her when he drew the similarly striking profile and neck of Mrs. Richard D. Sears in Boston in 1916, Plate 33. That same year he exhibited the once-notorious painting of "Mme. X" in America for the first time, before selling it to the Metropolitan Museum of Art.)

From the mid-1880s Sargent's interest in progressive French artists like Manet and the Impressionists became more pronounced. Although not conspicuous in his commissioned paintings, an overall looseness of effect is evident in informal drawings such as Plates 3, 6, 7 and 8. The late-1880s pastel of artist Paul Helleu smoking a cigarette (Plate 6), for example, recalls the work of Manet. It appears casual, deals with uneven indoor light and uses mood and atmosphere rather than detailed observation to evoke personality. This summarizing vision, involving rapid execution and an instantaneous impression, formed Sargent's style in the hundreds of charcoal portraits that followed. One of the earliest is that of American illustrator Edwin Austin Abbey (Plate 9), which was reproduced in *Harper's Monthly* with an essay by Henry James in 1889.[1] Abbey is shown darting a glance to the side, with a hint of a smile; rather than completely define the edges of the spectacles, the artist reproduced only those features that were most striking as he hastily looked and drew. Large, but not life-size, the drawing has a very realistic impact; nonetheless, its essential sketchiness — the bold visual evidence of the artist's hand — precludes the notion of photographic detail.

[1] Henry James, "Our Artists in Europe," *Harper's New Monthly Magazine*, 79 (June 1889), p. 55.

Plates 14 and 15 are excellent examples of commissioned charcoal portraits from the early years of this century, when Sargent made them with increasing frequency. Both show complete technical confidence and delight in rendering sensuous black areas such as the baroque confusions of the hats and coiffures. The large dark sections were set down quickly with long, heavy strokes, and sometimes softened with smudging. The paler tonalities of the faces were added carefully. Brash yet effective heavy black outlines push the heads into the sharpest relief. An eraser was used for the brightest highlights, creating sparkling passages with a "painterly" flourish that recalls impastoed accents in Sargent's paintings. These drawings of *grandes dames* encapsulate the theatrical magnificence of Edwardian society, and their spirit is not exceeded in other works by Sargent.

Plate 16, a drawing of Ethel Smyth in a mannish jacket, head uplifted, mouth open, eyes flashing, seems startlingly eccentric. She was a composer and close friend of the artist who enjoyed his creative whims. To capture her passionate presence Sargent asked her to sit at the piano and sing the most exciting songs she knew as he drew her. In contrast, the artist found William Butler Yeats (Plate 17) boastful and pretentious. "When he sat for me he wore a velvet coat and a huge loose bow tie, and a long lock of hair fell across his brow. He told me that he did these things to remind himself of his own importance as an artist!"[2] This powerful personality inspired a first-rate performance from Sargent, although the image suggests an arrogant undergraduate aesthete when in fact Yeats was in his early forties. The drawings of ballet dancers Karsavina and Nijinsky (Plates 20 and 21) seem both emotional and artificial. Sargent manipulated the medium with expressive abandon to capture the blurred, fleeting memory of exhilarated moments in their performances. They are instances of his love for bizarre theatricality, records of the dancers' interpretations of their parts and uncanny perceptions of the youth, beauty and energy beneath the heavy makeup.

Plates 12, 13 and 30 are distinctive and touching responses to elderly people. The drawing of Henry James (Plate 26) captures the nervous watchfulness crucial to that writer's sensibility, while two of the older English ladies (Plate 27 and Frontispiece) recall types of intelligent, lovely, compassionate, yet sad women that appear in James's fiction. There is diversity in the drawings of Sargent's friends and colleagues in the arts: musicians (Plates 36, 37, 39), composers (Plates 10, 16), actors (Plates 14, 18), dancers (Plates 20, 21), writers (Plates 17, 24, 26) and artists (Plates 1, 2, 3, 6, 9, 23, 38). In a work made for himself, Sargent drew a working-class Italian he employed as a model for his murals (Plate 29), but in place of his signature he wrote the subject's name and address (which suggests the piece dates from their first session). He was moved by the forthright sculptural vigor of the Italian's head, and the drawing has an impact equal to that made by a portrait of an English aristocrat of similar age (Plate 28). Of course, the image of the highly bred, perfectly groomed officer bespeaks a sophisticated life rich in outlook, while that of the young Italian is ultimately sad.

Since they are numerous and of varying quality, and were to some extent substitutes for paintings, the charcoal portraits have become the least familiar and most readily dismissed part of Sargent's oeuvre.[3] This was not always the case, for when about 50 were exhibited in London in 1916 Claude Phillips called them "swift transcripts of bright youth, saddened maturity, and resigned age, which taken as a whole show the most attractive side of his wonderful talent."[4] He felt that Sargent rarely gave deep insight in his work, but acknowledged his particular interest and great success in capturing "the brilliant moment in life, the moment of youth and graceful triumph, of fashion at its climax, of dignity, of success." A single sitting provided the perfect limit to inauspicious collaborations with the eminent and rich. Should the drawing go awry during the session Sargent would immediately begin again. Wisely, he did not expect each work to be great, and admitted: "at the risk of seeming a crank, I must tell you that I succeed much better in drawing a sketch on a first impression than when I have seen a face before."[5] Given such a brief encounter, it is astonishing that the moods and perceptions in these portraits range so freely from tenderness and conventional idealized charm to unself-conscious frankness.

[2] Sargent quoted by Martin Birnbaum in *John Singer Sargent* (New York: W. E. Rudge's Sons, 1941), p. 26.

[3] Recently a group of portrait drawings made an important contribution to the exhibition and catalogue by James Lomax and Richard Ormond, *John Singer Sargent and the Edwardian Age* (Leeds Art Galleries, National Portrait Gallery, London, and Detroit Institute of Arts, 1979).

[4] Claude Phillips, "Grafton Galleries. Sargent's Portrait Drawings," 1916 clipping at Frick Art Reference Library, New York.

[5] Sargent to Mrs. Lyman, January 19, 1920 (private collection).

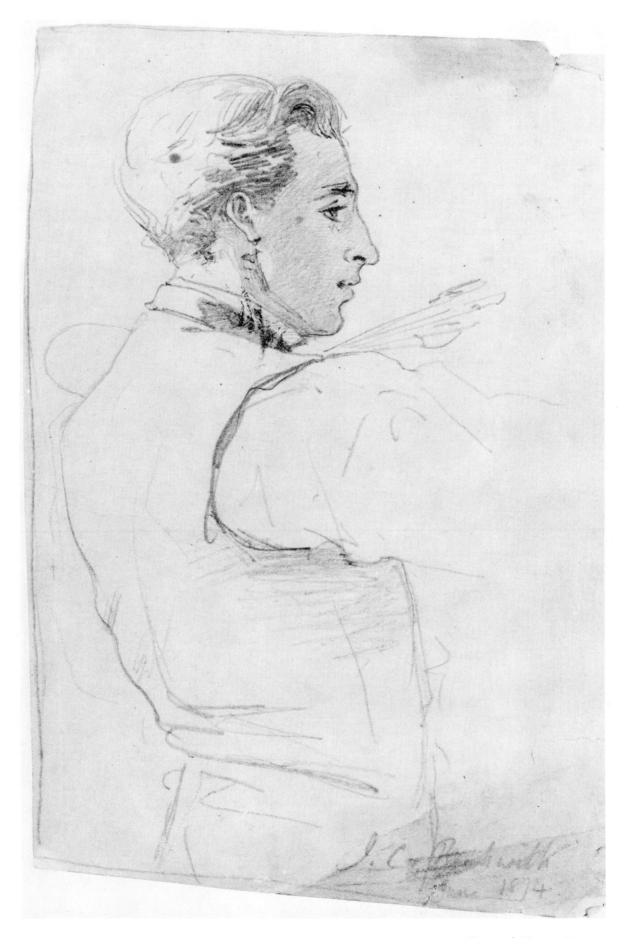

1. J. CARROLL BECKWITH, 1874. Pencil, 9 x 6. Fogg Art Museum, Harvard University.

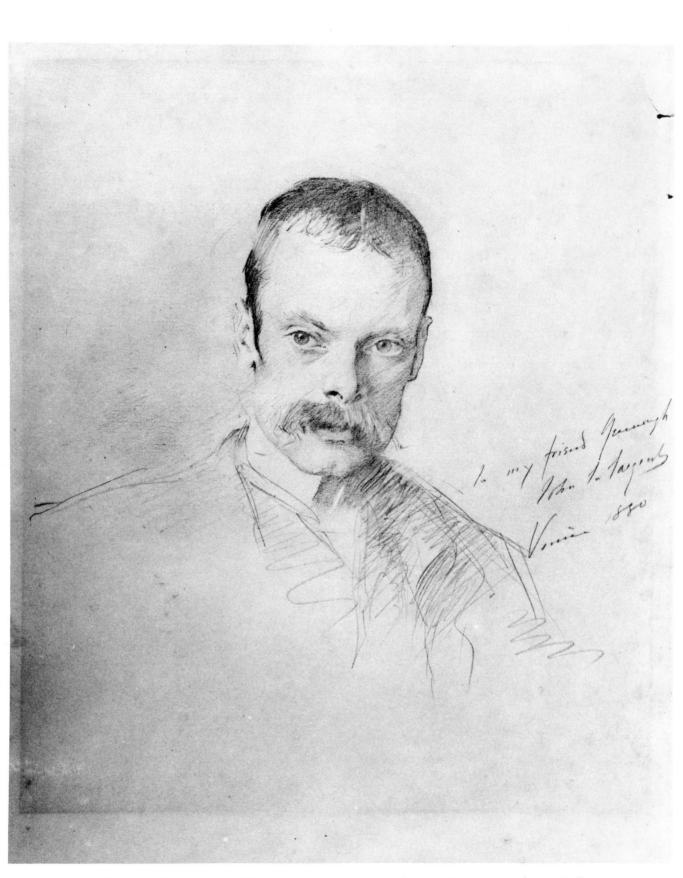

2. GORDON GREENOUGH, 1880. Pencil, 11 x 9. Mead Art Museum, Amherst College.

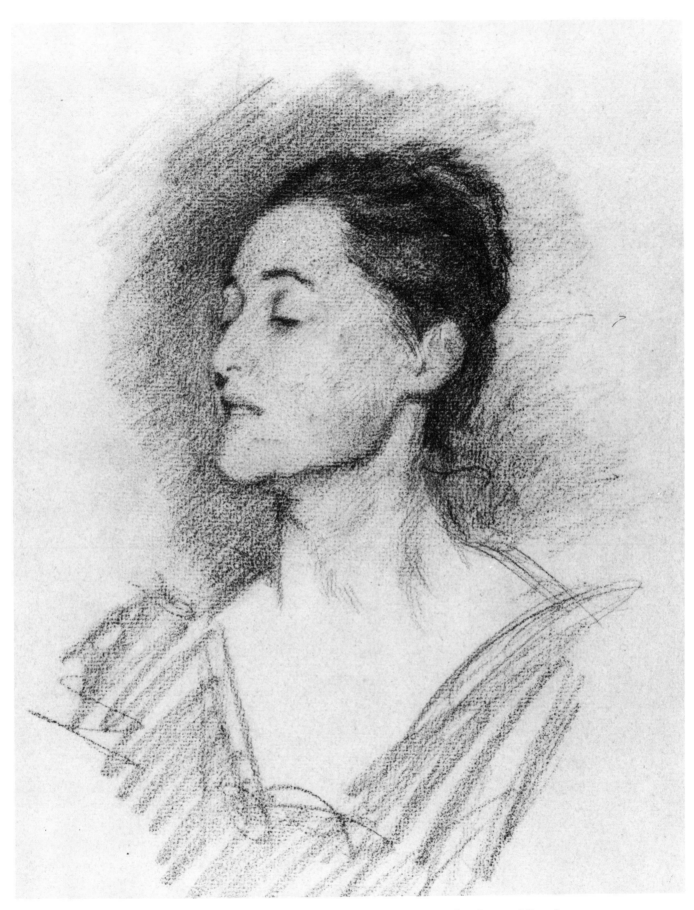

3. FLORA PRIESTLEY, late 1880s. Pencil, 11½ x 8½. The Ormond Family.

4. MME. PIERRE GAUTREAU, ca. 1883. Pencil, 9⅝ x 10¹/₁₆. Fogg Art Museum, Harvard University.

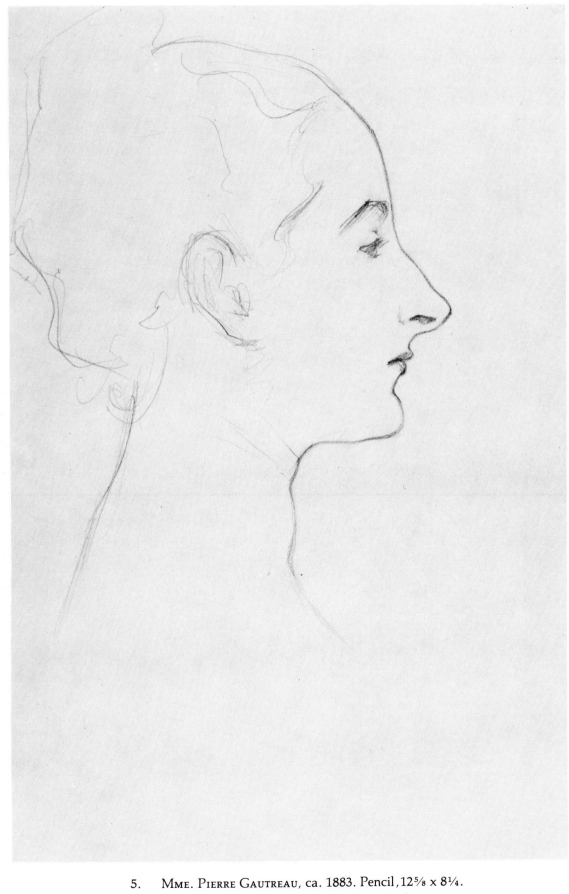

5. MME. PIERRE GAUTREAU, ca. 1883. Pencil, 12⅝ x 8¼.
Metropolitan Museum of Art, New York.

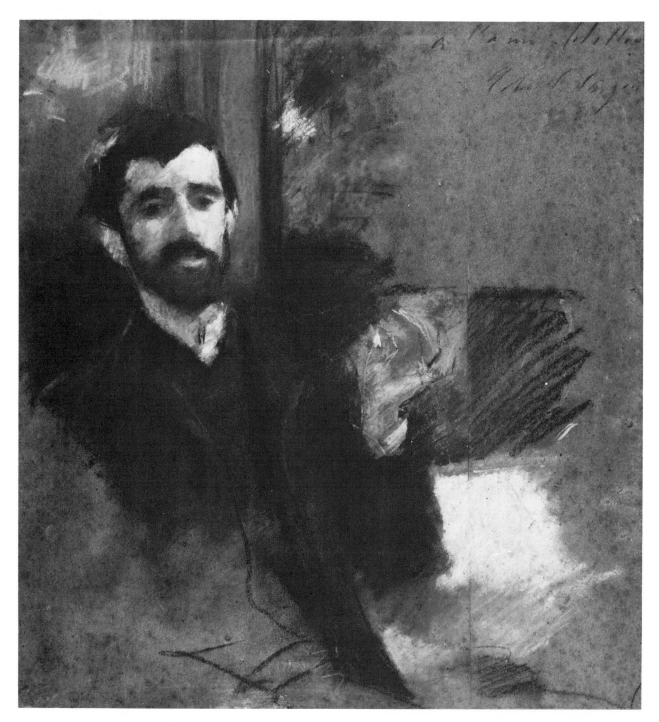

6. PAUL HELLEU, late 1880s. Pastel, 19½ x 17⅝. Fogg Art Museum, Harvard University.

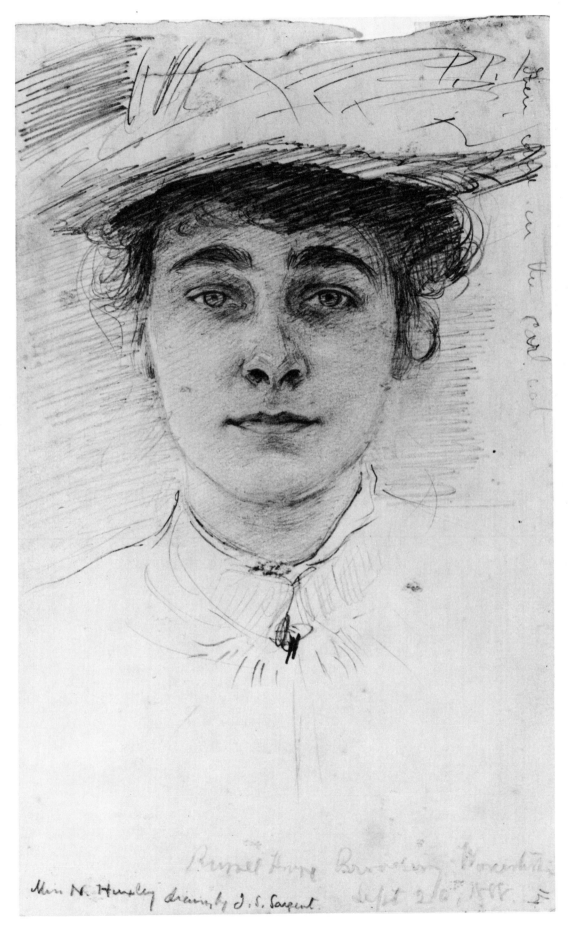

7. NETTIE HUXLEY, 1888. Pencil, 9¼ x 5⅞. Yale University Art Gallery.

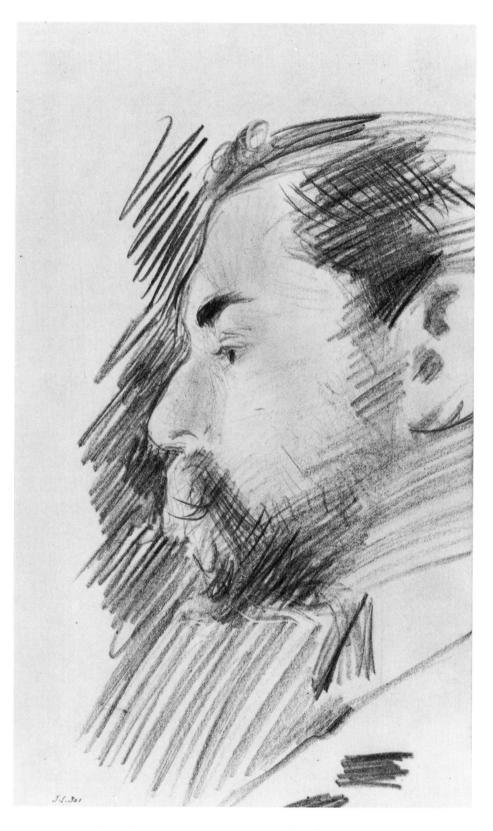

8. SELF-PORTRAIT, late 1880s? Pencil, 8⅜ x 4⅞.
Fogg Art Museum, Harvard University.

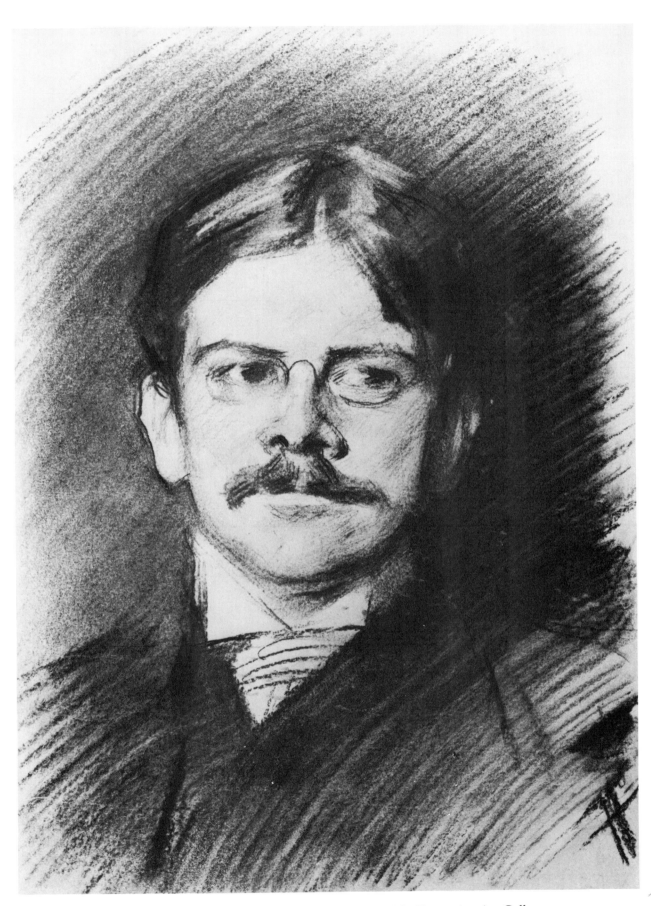

9. EDWIN AUSTIN ABBEY, 1888. 14 x 10⅛. Yale University Art Gallery.

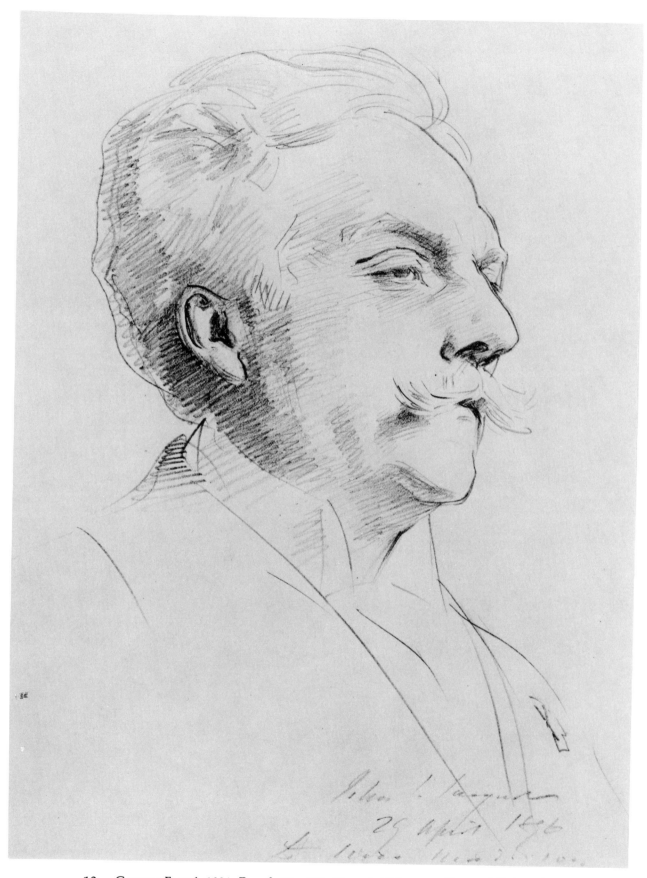

10. GABRIEL FAURÉ, 1896. Pencil, 10 x 7¼. Fogg Art Museum, Harvard University.

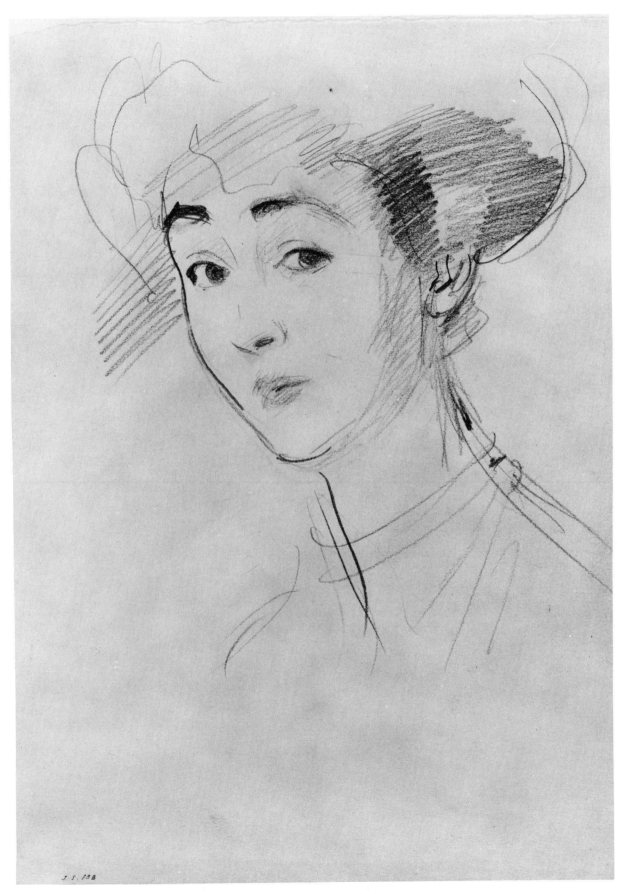

11. DUCHESS OF MARLBOROUGH, ca. 1904. Pencil, 11¼ x 7⅞.
Metropolitan Museum of Art, New York.

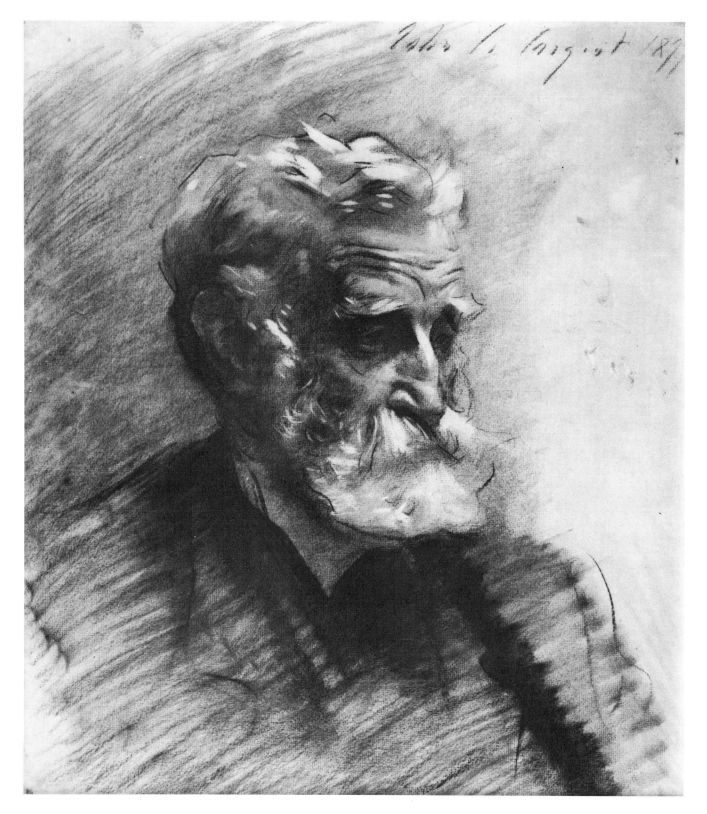

12. EDWARD AUGUSTUS SILSBEE, 1899. Bodleian Library, Oxford.

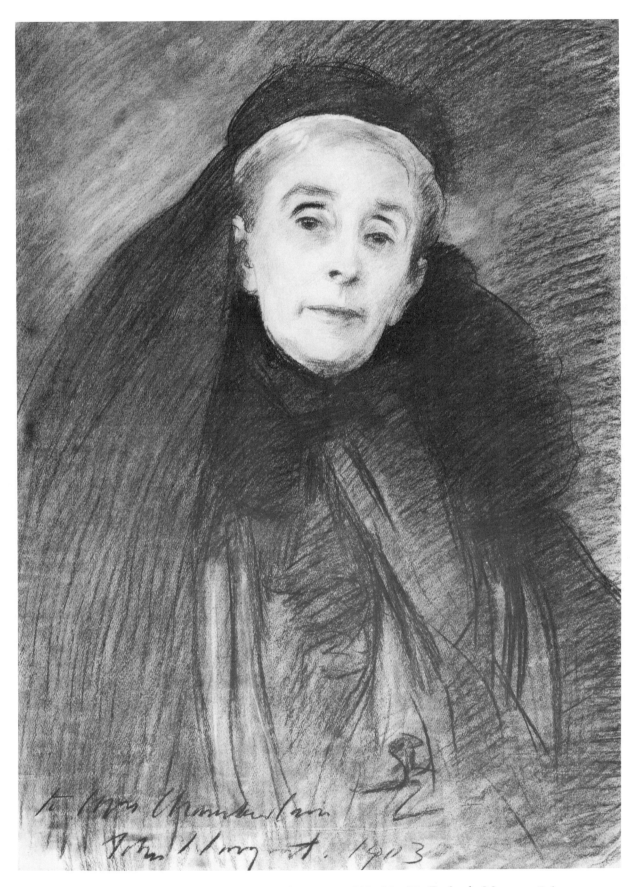

13. Mrs. William Crowninshield Endicott, 1903. 29 x 20. Peabody Museum, Salem.

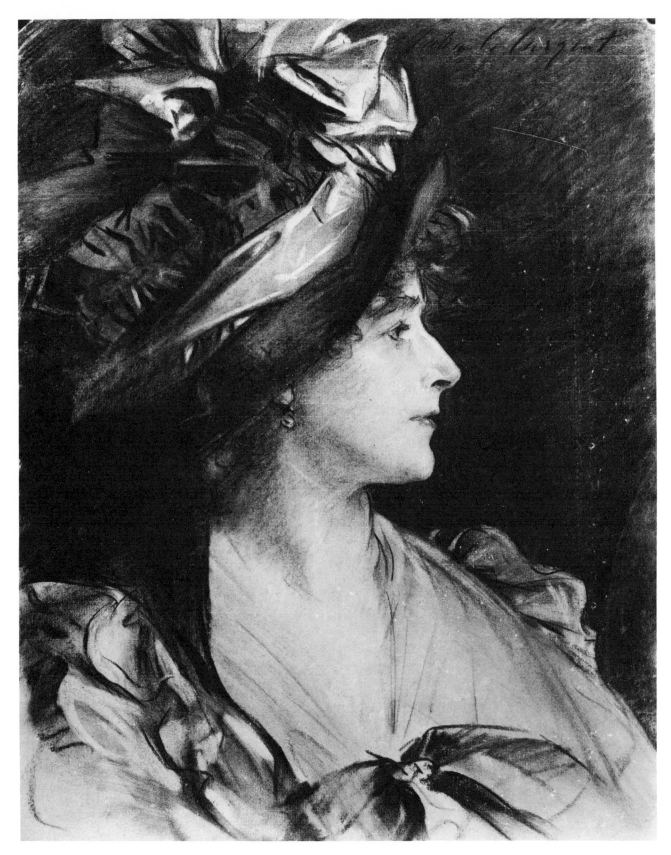

14. GERTRUDE KINGSTON, ca. 1905? 24 x 18. King's College, Cambridge.

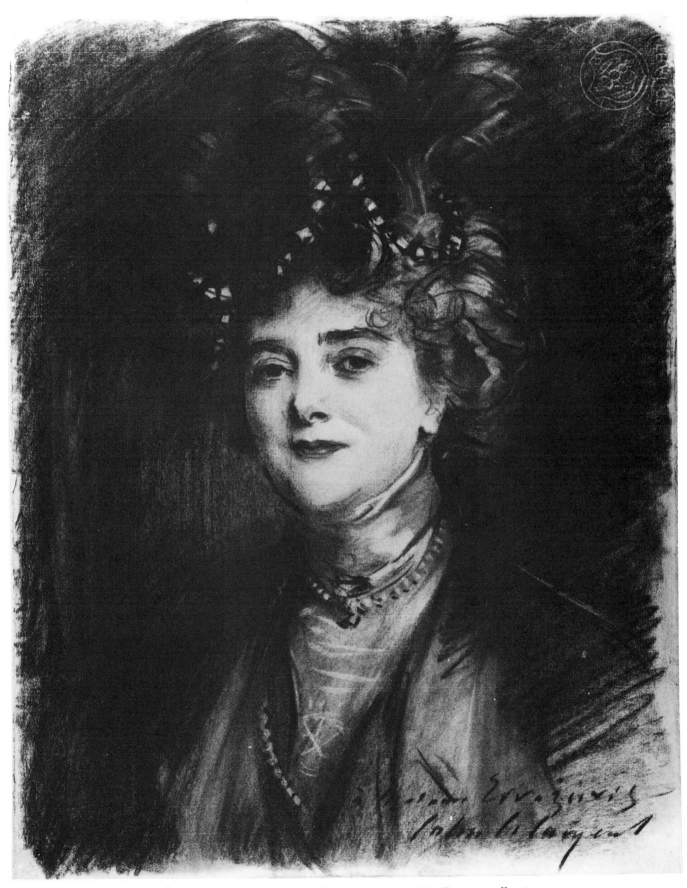

15. Mme. Eugénia Huici Errazuriz, ca. 1905. Private collection.

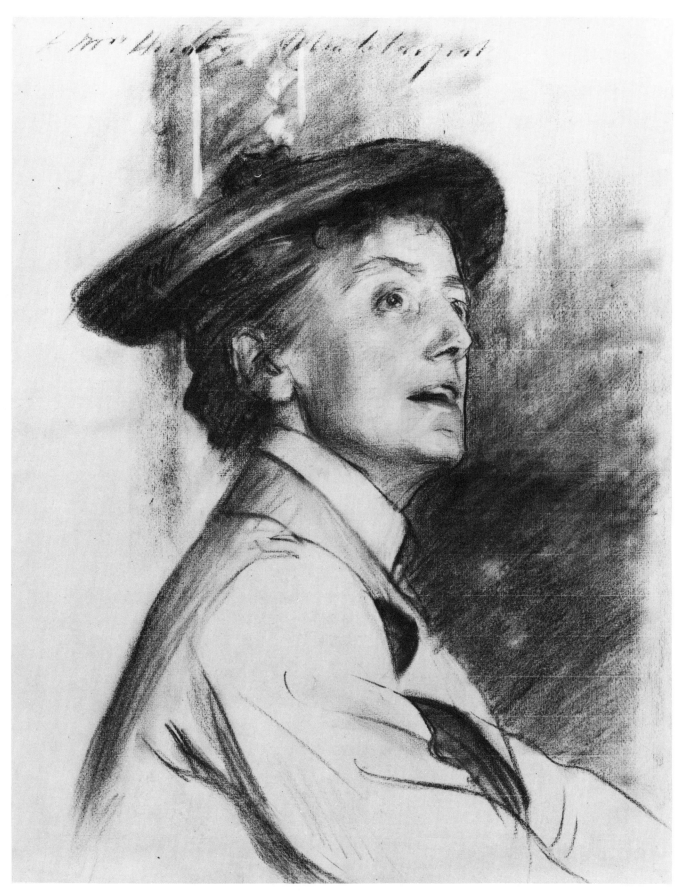

16. DAME ETHEL SMYTH, 1901. 23½ x 18⅛. National Portrait Gallery, London.

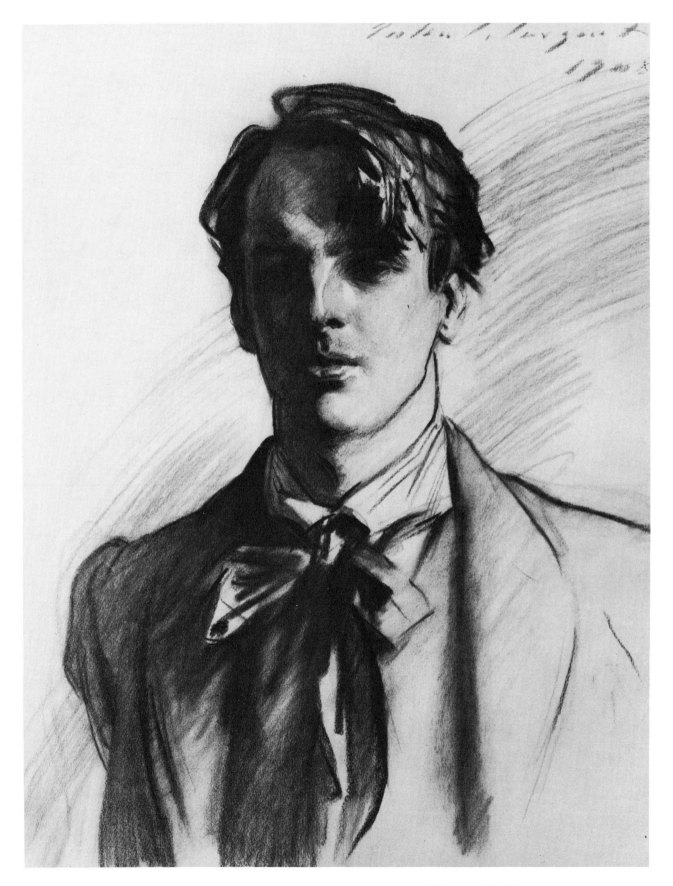

17. WILLIAM BUTLER YEATS, 1908. 24½ x 18¼. Private collection.

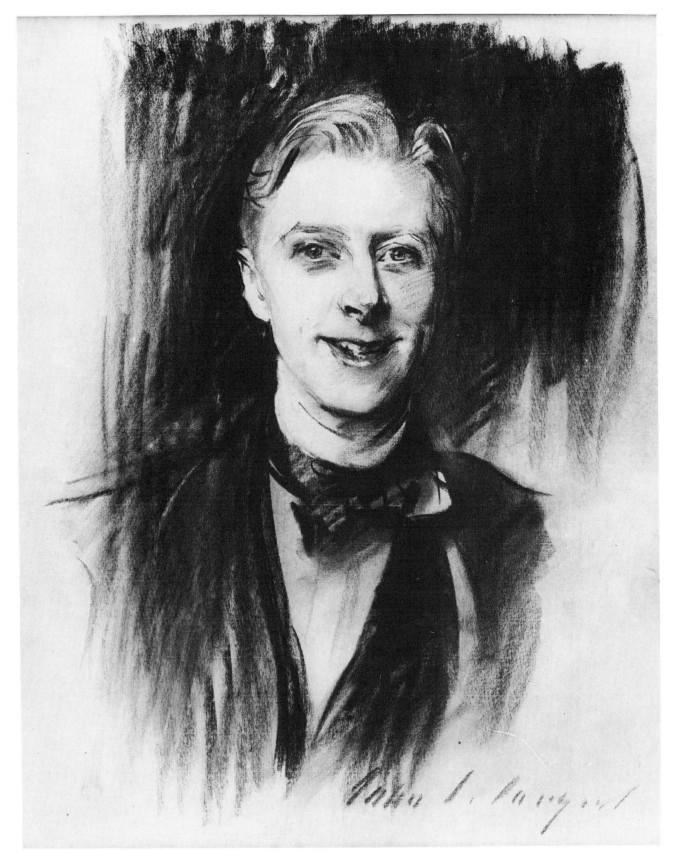

18. ERNEST THESIGER, ca. 1911. Private collection.

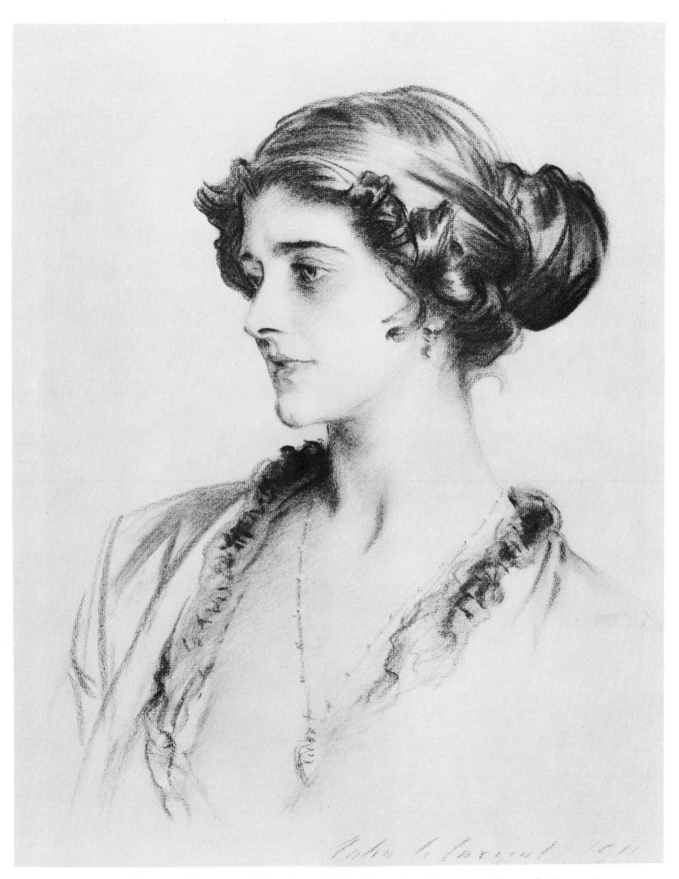

19. MRS. HORACE WEBBER, 1911. 22 x 16¾. Fogg Art Museum, Harvard University.

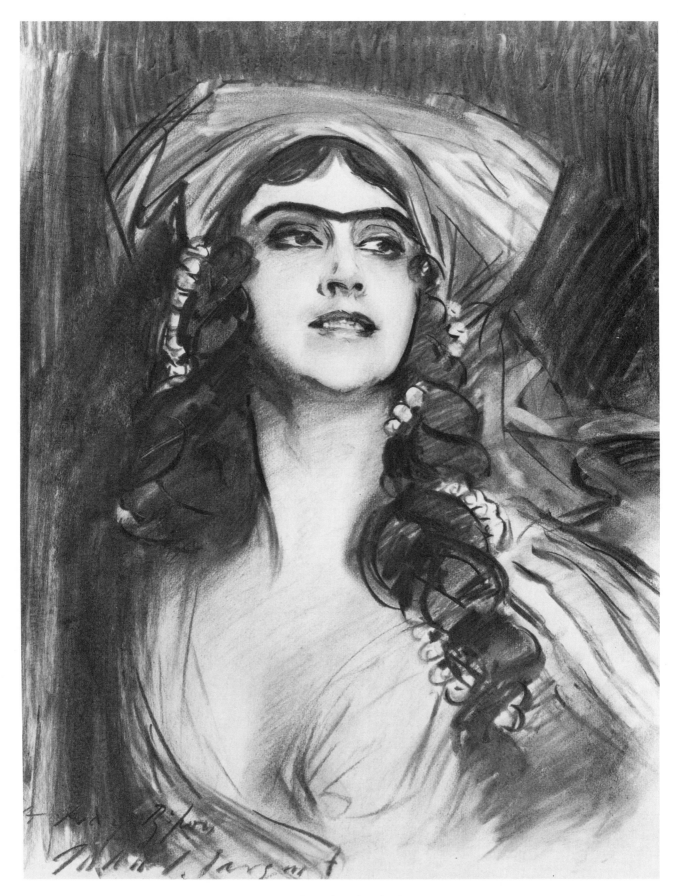

20. TAMARA KARSAVINA in the title role of *Thamar*, 1911. 23½ x 17¾.
Fogg Art Museum, Harvard University.

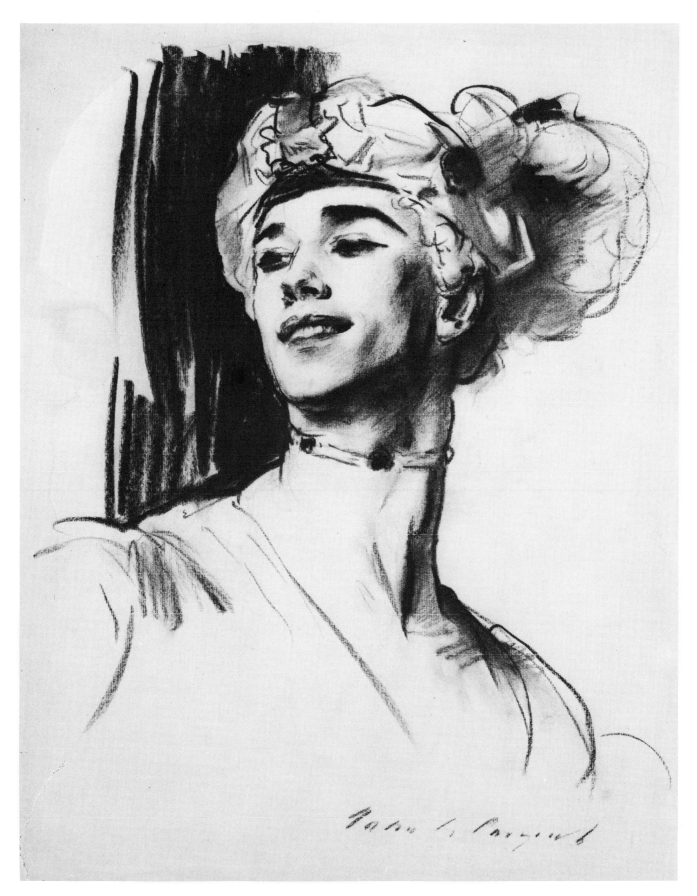

21. VASLAV NIJINSKY in *Le Pavillon d'Armide*, 1911. 24¹/₁₆ x 18⁵/₈.
Private collection.

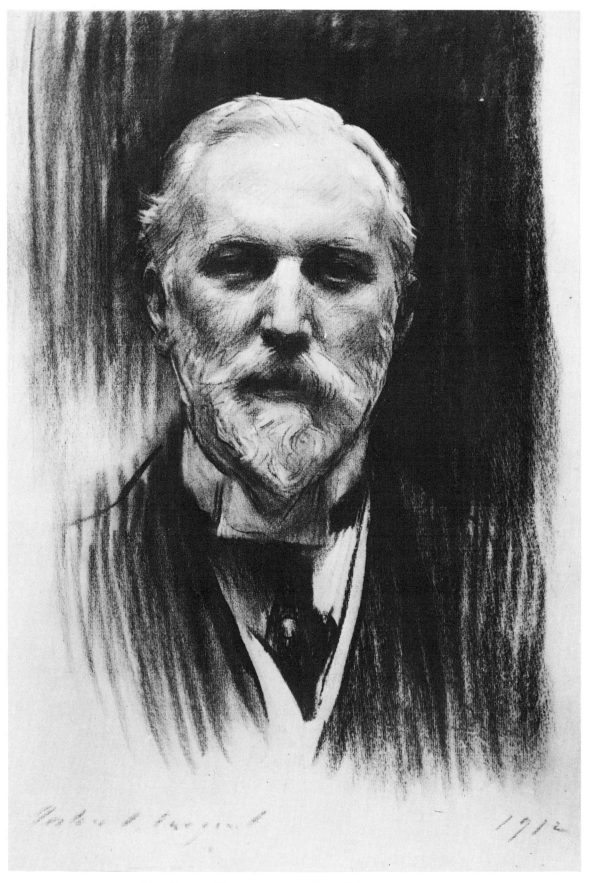

22. ROBERT HENRY BENSON, 1912. Private collection.

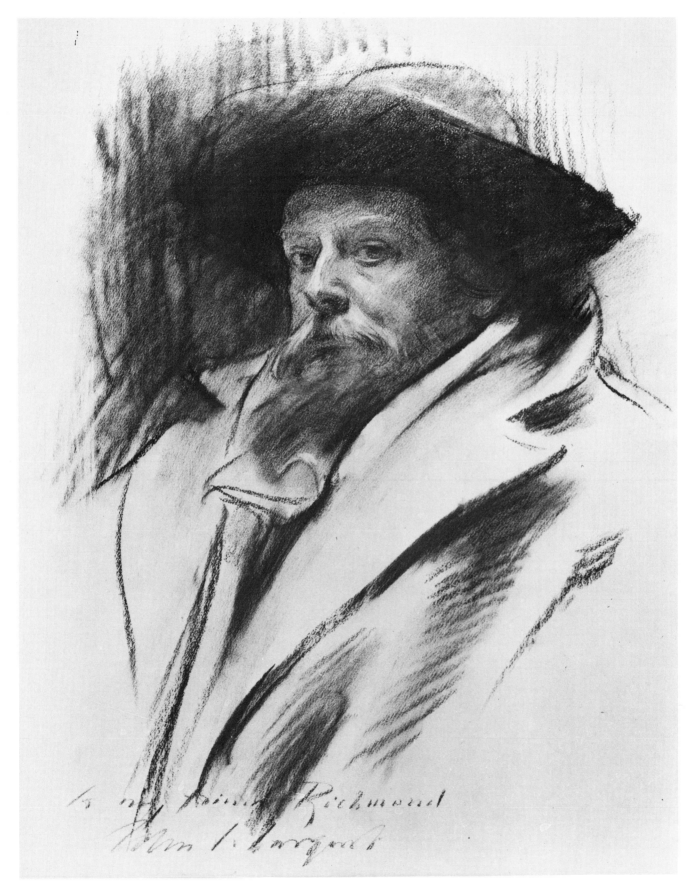

23. Sir William Blake Richmond, ca. 1912. Private collection.

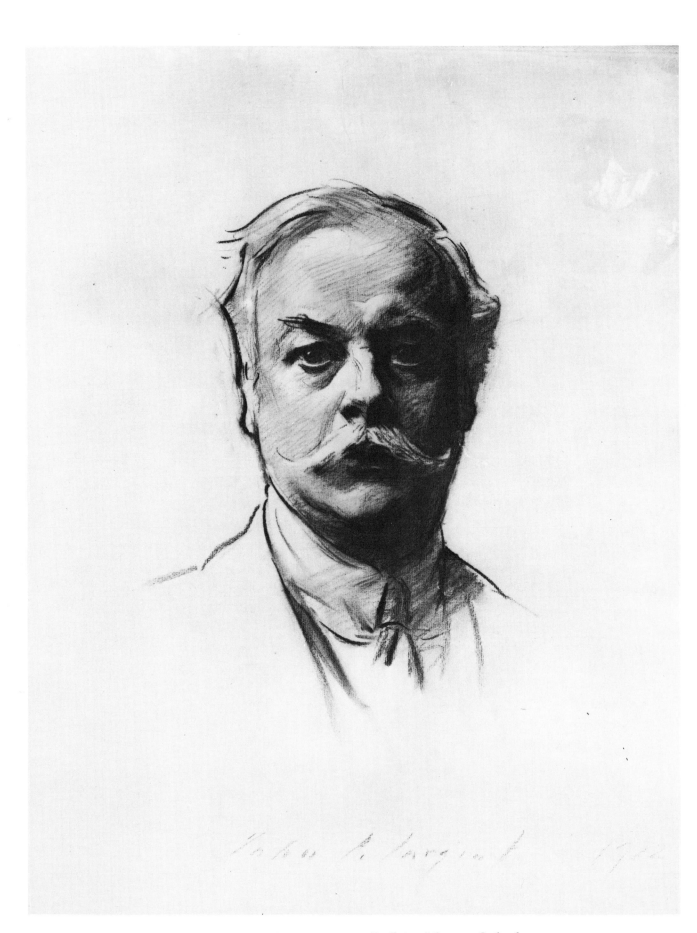

24. KENNETH GRAHAME, 1912. Bodleian Library, Oxford.

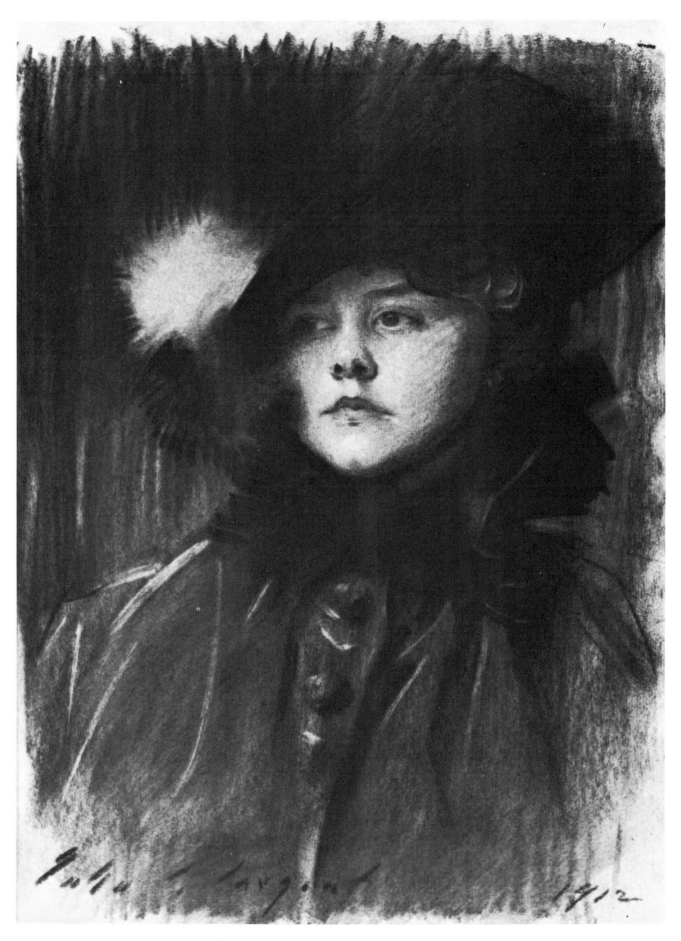

25. HELEN SEARS, 1912. 23¾ x 17½. Private collection.

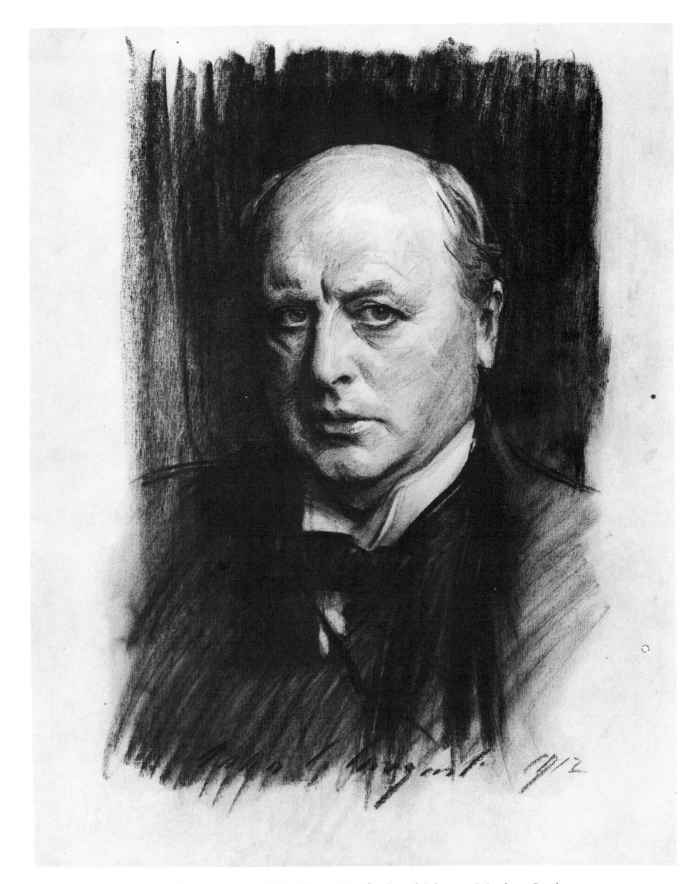

26. HENRY JAMES, 1913. 24½ x 16. The Royal Library, Windsor Castle.

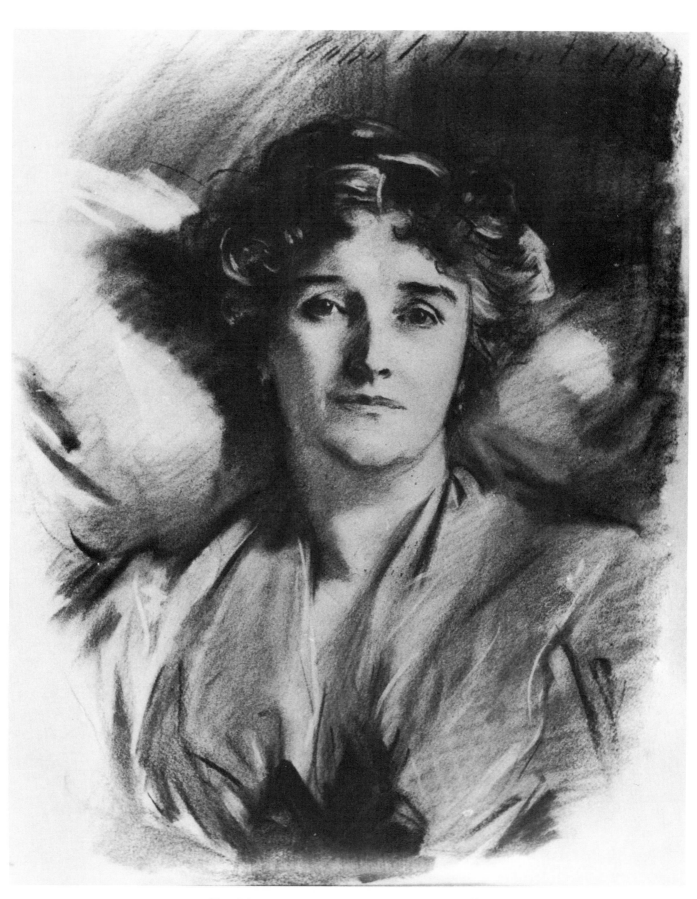

27. THE MARCHIONESS OF BATH, 1913. Private collection.

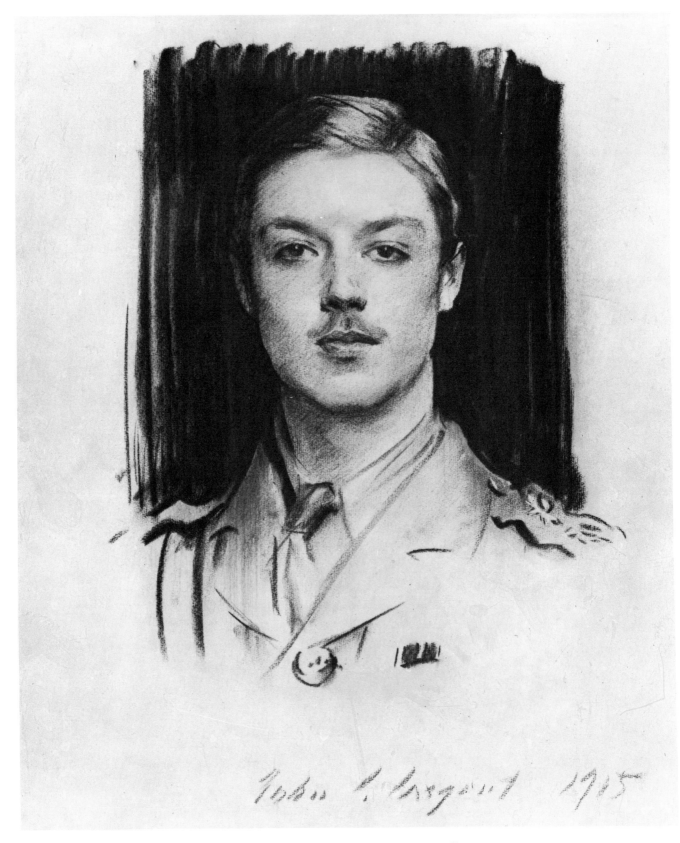

28. VISCOUNT ALTHORPE, 1915. Private collection.

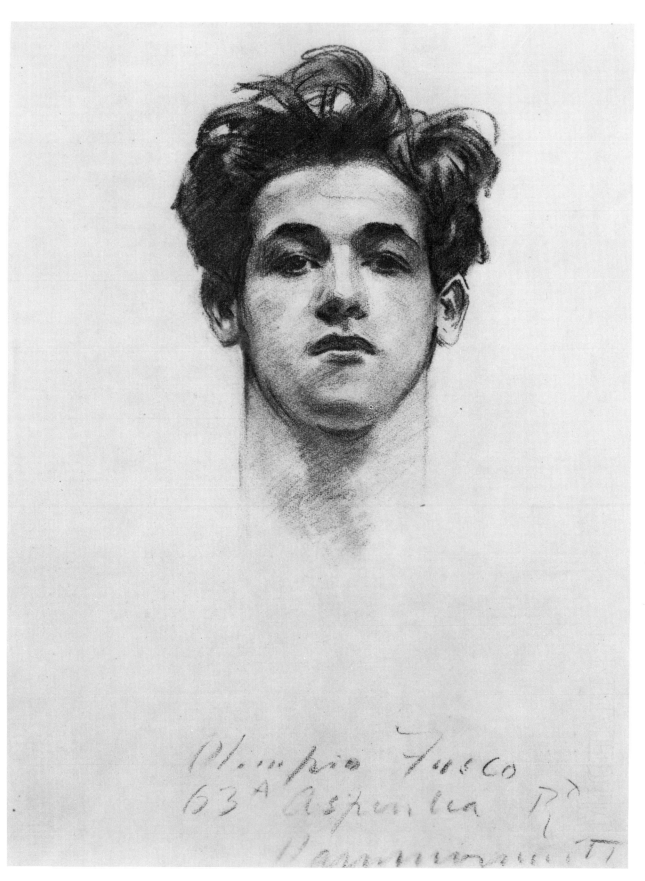

29. OLIMPIO FUSCO, 1905–15? 22 x 17. The Corcoran Gallery of Art, Washington.

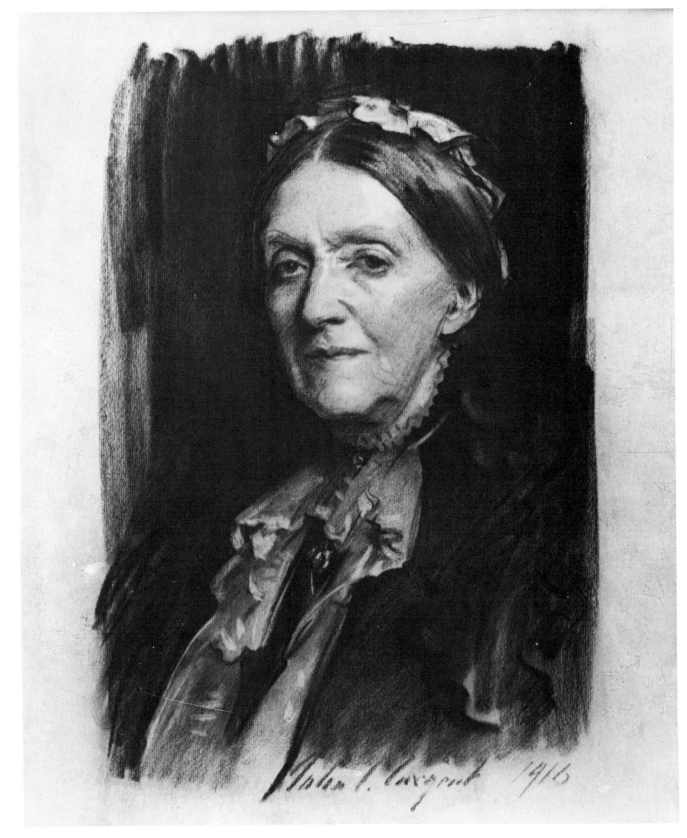

30. LADY SARAH SPENCER, 1916. Private collection.

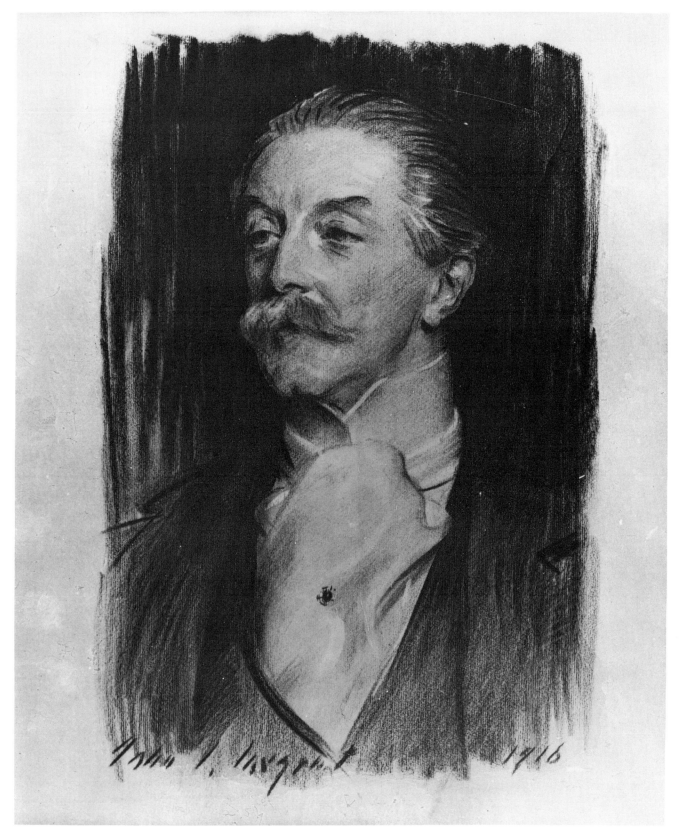

31. 6TH EARL SPENCER, 1916. Private collection.

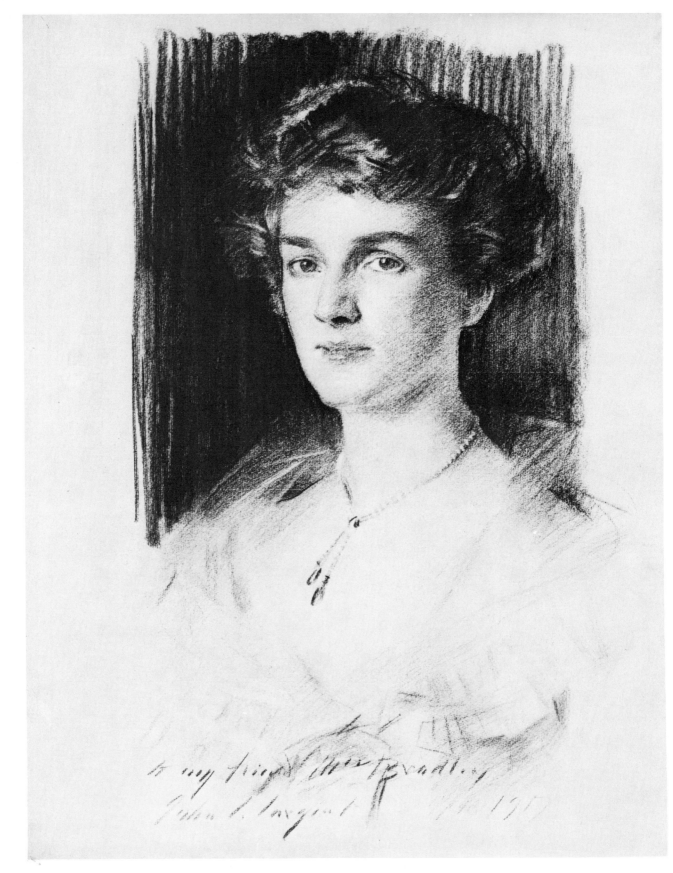

32. MRS. ROGER D. SWAIM, 1917. 25 x 18½. Private collection.

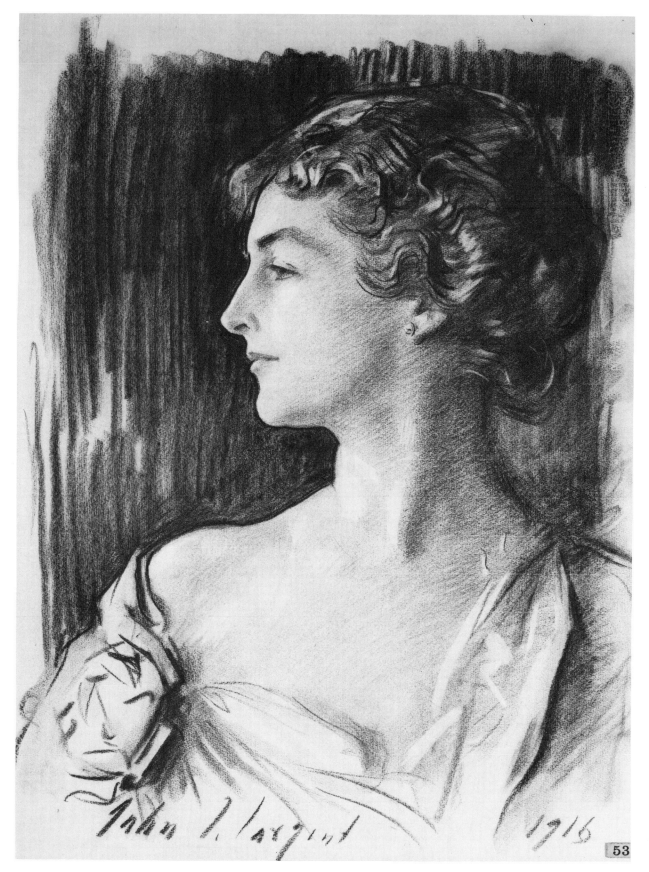

John S. Sargent 1916

53

33. Mrs. Richard D. Sears. 1916. 24½ x 18⅛. Private collection.

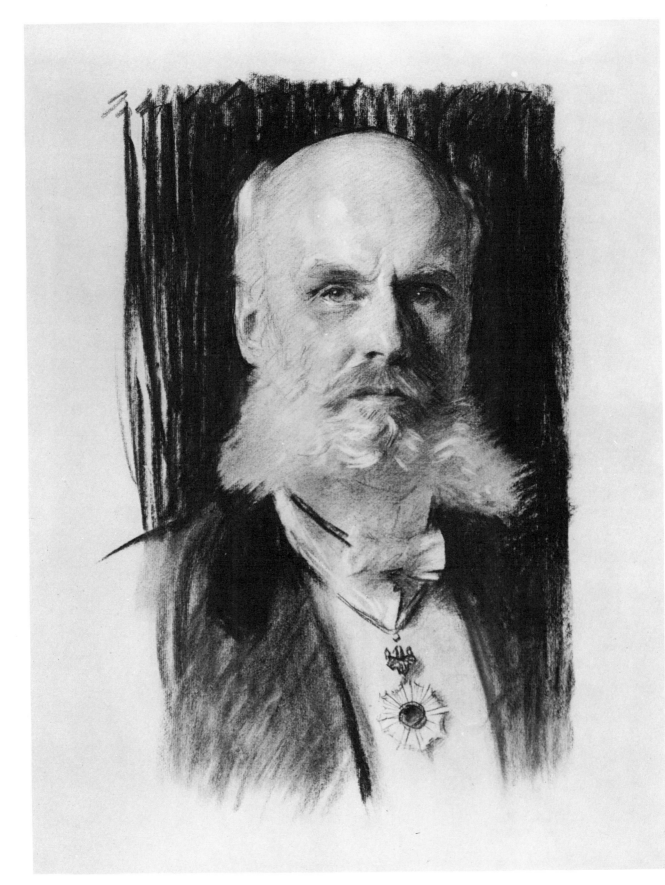

34. William Sturgis Bigelow, 1917. 24¾ x 18⅞. Museum of Fine Arts, Boston.

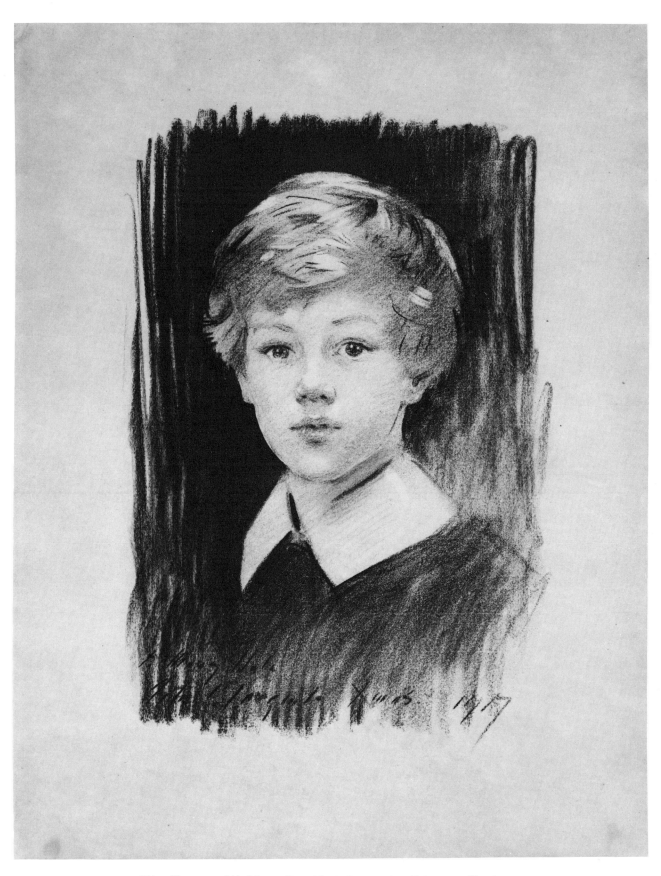

35. RICHARD W. HALE, JR., 1917. 24 x 17¾. Private collection.

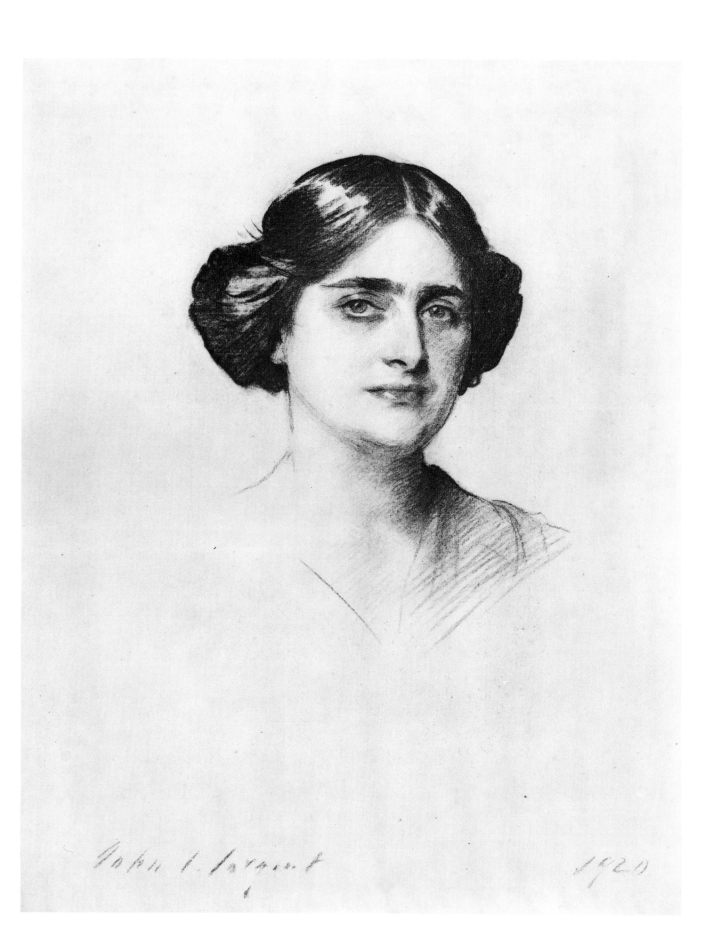

36. MYRA HESS, 1920. 23½ x 18⅛. Private collection.

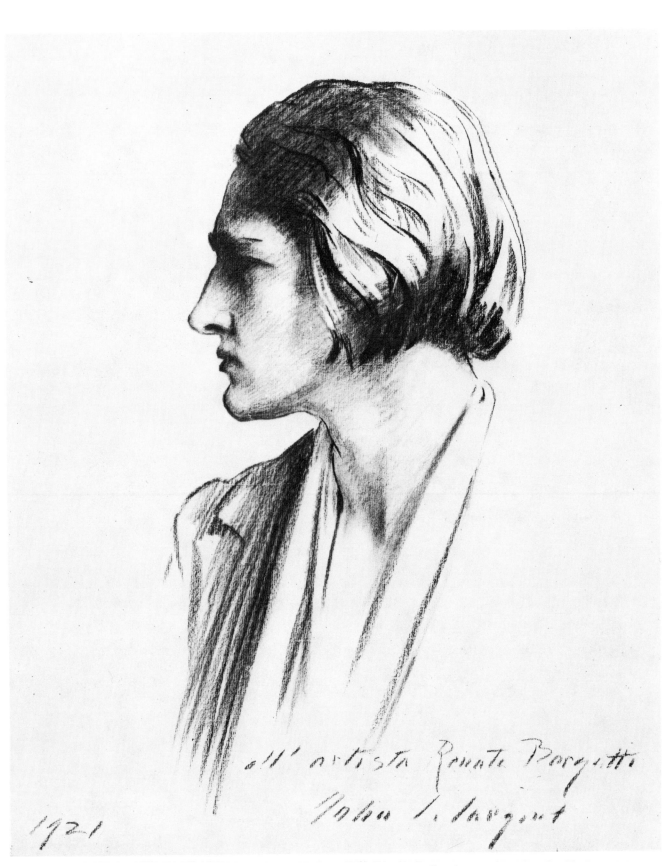

all' artista Renata Borgatti

John S. Sargent

1921

37. RENATA BORGATTI, 1921. Private collection.

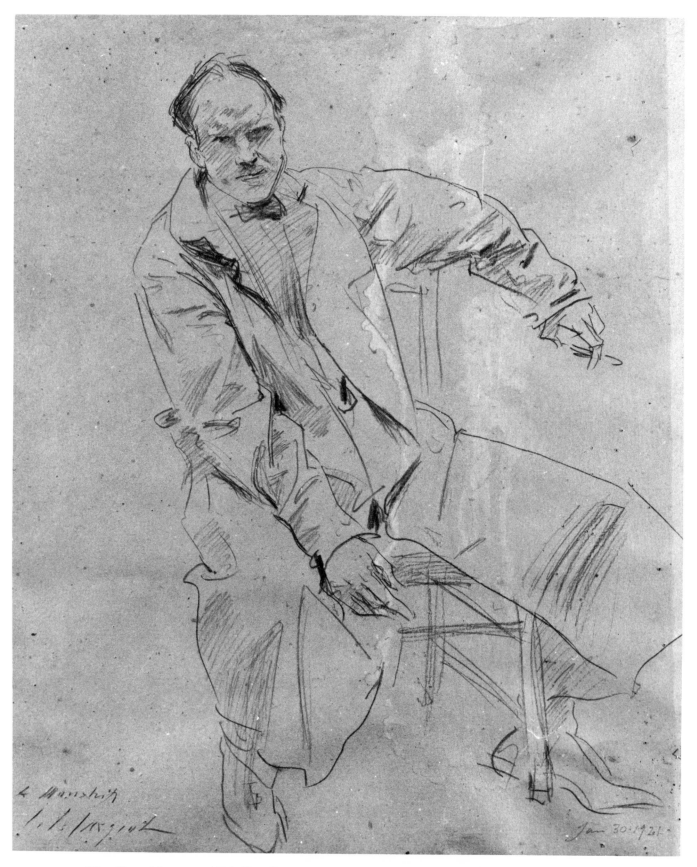

38. PAUL MANSHIP, 1921. Pencil, 21¼ x 16⁷/₁₆. Metropolitan Museum of Art, New York

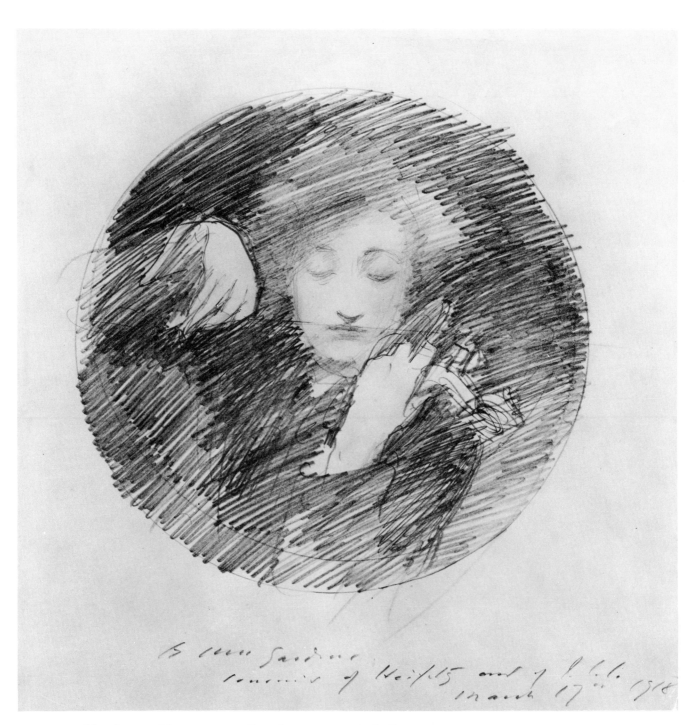

39. JASCHA HEIFETZ, 1918. Pencil, 9½ x 8¾. Isabella Stewart Gardner Museum, Boston.

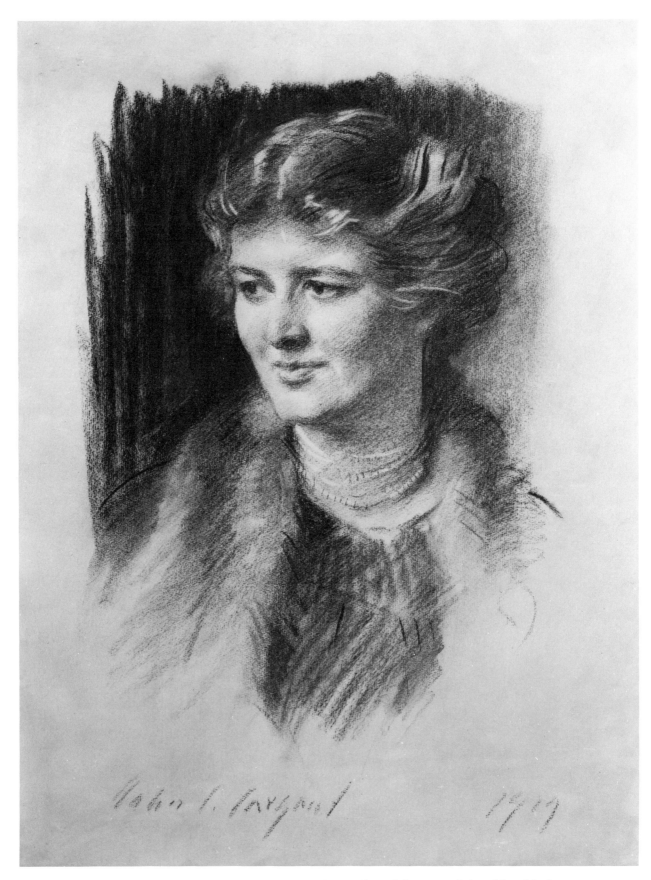

40. MRS. JOHN BEALS MILLS, 1919. Metropolitan Museum of Art, New York.

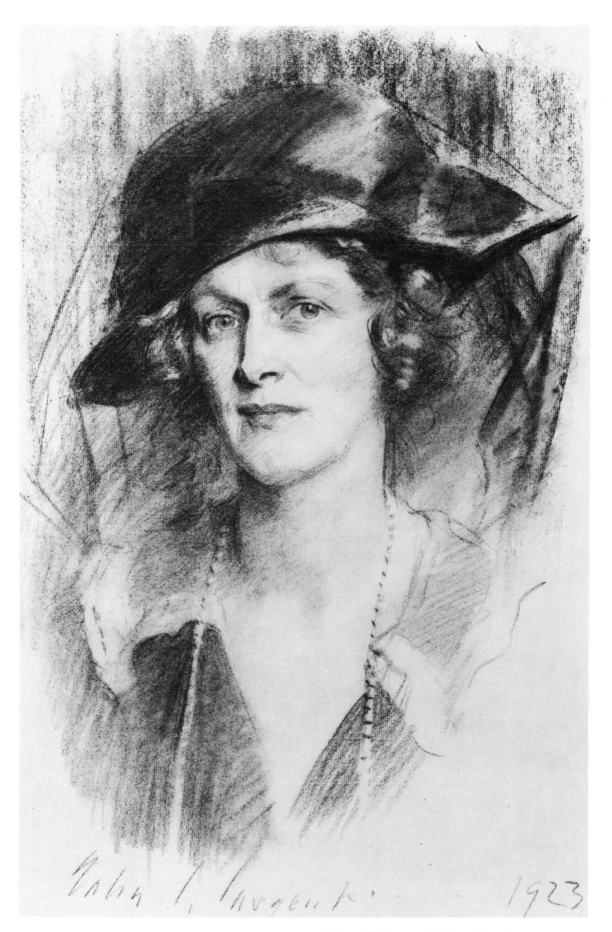

41. VISCOUNTESS ASTOR, 1923. 22 x 15. National Portrait Gallery, London.